SLOW DOWN

and Draw Something

www.castlepointbooks.com

The Castle Point Books trademark is owned by Castle Point Publishing, LLC.

Castle Point books are published and distributed by St. Martin's Publishing Group.

Design by Noora Cox
Edited by Monica Sweeney
Images used under license by Shutterstock.com

ISBN 978-1-250-32412-2 (trade paperback)

Our books may be purchased in bulk for promotional, educational, or business use. Please contact your local bookseller or the Macmillan Corporate and Premium Sales Department at 1-800-221-7945, extension 5442, or by email at MacmillanSpecialMarkets@macmillan.com.

First Edition: 2024

10 9 8 7 6 5 4 3 2 1

SLOW DOWN
and Draw Something

Continue the
Meditative Doodles
to Calm Your Mind

KALEI HUGHES

CASTLE POINT BOOKS
NEW YORK

Draw slowly, breathe deeply, and imagine endlessly

DRAWING IS YOUR MEDITATIVE AND CREATIVE WELLSPRING.

Imagine drawing slowly, mindfully, and peacefully for fifteen minutes a day. Does the graze of the pen quiet the noise around you? Does the ink's slow getaway from strict lines to fuzzy edges soften your mood? What if this moment of artful calm, with swirling flourishes and entrancing patterns, were your own personal escape? On the pages of *Slow Down and Draw Something*, you are given the inspiration and the tools to carve out peaceful moments, to invite creativity into your routine, and to slow down.

EMBRACE SLOWING DOWN

Anyone can start drawing, and everyone can train themselves to slow down and draw. Whether you schedule time on your calendar, set an alarm each day, or use sensory cues like the glow of the first sunbeam in the morning, the smell of that first cup of coffee, or the snap of a closing laptop at the end of a workday, you can make slowing down a welcome part of your routine. Taking time each day to pull yourself out of the hustle and bustle is proven to help you feel calmer, improve your mood, sleep better, spark creativity, and sharpen focus in many areas of your life. Even when there's no end in sight to the work that needs to be done or the boxes that need to be checked on your to-do list, stealing moments just for yourself will help clear your mind and recharge your spirit.

SET YOURSELF UP FOR TRANQUILITY

Make your drawing time your escape. Find a comfortable place to sit and cloak yourself in calm. Turn off loud or bright distractions that tend to increase stress, like cell phone notifications and harsh overhead lights. Gather a quality smudge-proof pen or your favorite writing instrument, and relax as you seclude yourself in your very own drawing sanctuary.

DRAW TO EASE, RELEASE, AND FIND PEACE

You don't have to be a professional artist to harness beauty or achieve growth through drawing. Each drawing page provides pattern swatches and doodle snippets so you can begin your meditative journey. Begin by mirroring the lines you see on the page. Hold your pen with a loose grip, controlling the flow of your movement without putting too much pressure on your muscles and joints. Immerse yourself in the pen strokes and the embellishments you add to the page. Use details from the patterns to lead you, but don't worry if your art isn't an exact match. Let it flow! What does the movement of the pen stir in you? What do the shapes and doodles you create remind you of? What relaxing images come to mind and what sounds can you hear?

ADD FLOURISHES AND FINISHING TOUCHES

Experiment with your lines, shapes, and textures. Let the cadence of your pen against the page calm you with symmetrical lines; patterns closely clustered or loosely scattered; long, flowing strokes; or short, precise marks. Use inspiration from nature, like water droplets, freckles, starbursts, irises, wood grain, waves, snowflakes, and fractals to enhance your drawings. Your patterns might stretch to the border or stop short before the edge. Whatever soothes you, moves you, and keeps you feeling calm is where you want to be. If black ink doesn't feel like enough, bring in some hues. Soft colored pencils, soothing pastels, or even glitter enrich mindful creativity, just like drawing.

FEEL THE BENEFITS OF CREATIVE BREAKS

Remember that slowing down isn't a task—it's a reprieve. It's your personal retreat that will help you clear the cobwebs from your mind, reflect on your day, provide energy and creativity, and refill your cup. Let *Slow Down and Draw Something* be your source of serenity and a simple way to express your artistic side in small and reachable moments.

LET FLORALS BLOSSOM. Using gentle, elegant strokes, add more blooms to this bouquet and fill in the petals with slim, wavy lines. Continue with this pattern or introduce details like stems, leaves, and other natural shapes.

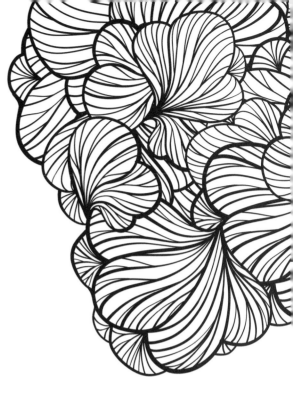

IMAGINE THE SPACE AROUND THE LEAVES.

Are they reaching for the sun, climbing up a wall, or swaying beneath the sea? Follow the path of these stretching stems by adding more leaves. Start with the shape of the whole leaf, add the center line, and then draw parallel veins for a lush green leaf.

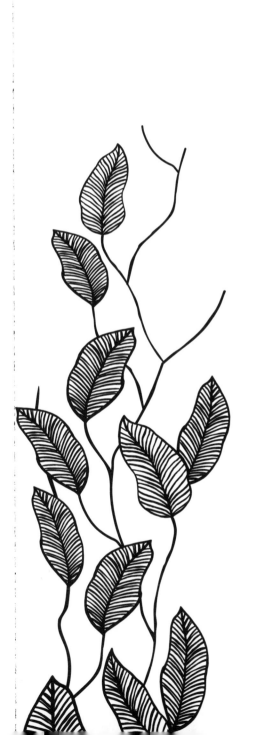

GO WHERE THE WAVES TAKE YOU.

Follow the movement of this pattern, but let the swirls, circles, lines, and arches come to you naturally. Play with different types of shading and shapes by mirroring some found here and then coming up with your own.

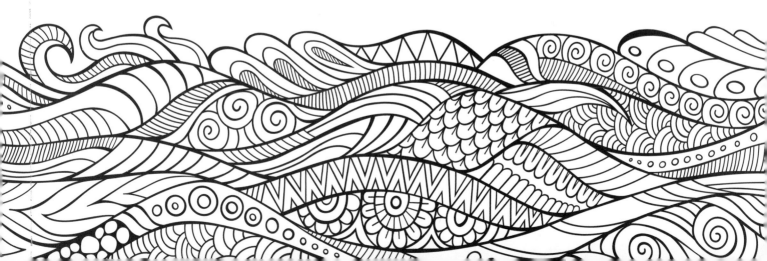

WOOD GRAIN, RIPPLING WATER, ETCHED GLASS.

These circles can mean something or nothing at all. Create a beautiful ripple effect. Start with the tiniest orb you can draw and gently build around it. Let the pattern be as full—like a downpour—or as sparse—like a drizzle—as you like.

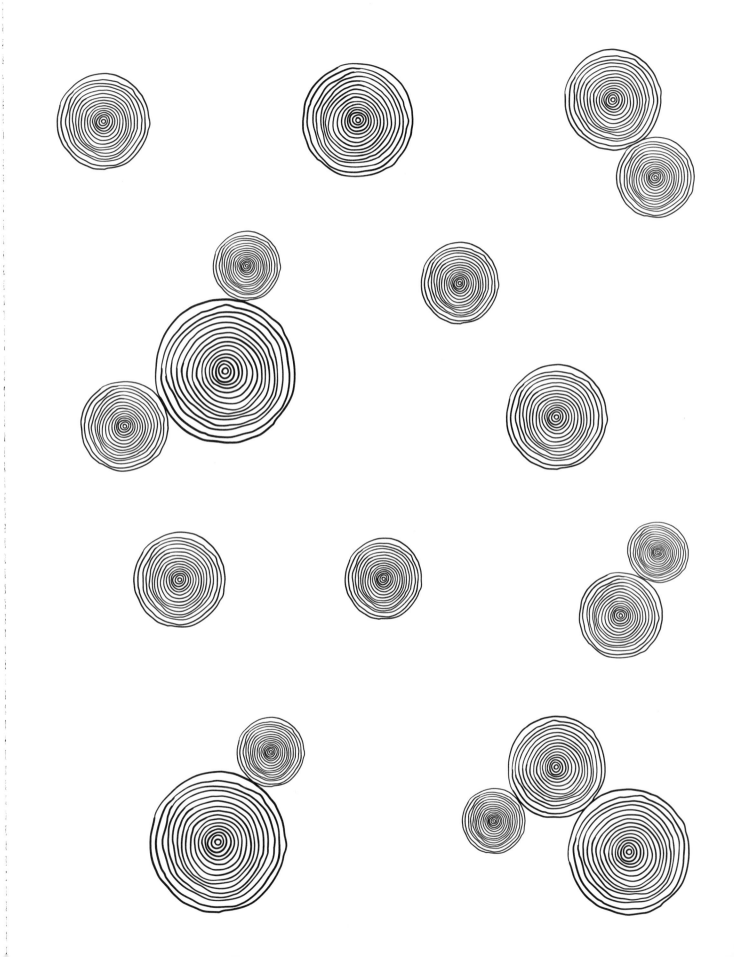

A CANDY LAND OF LOLLIPOPS or a forest of puffy clouds, this tuft of swirls is yours to imagine. Extend the ribbons of these shapes like bands of a rainbow. Etch circles in uniform streamers or play with their size. Let the whirls sweep you off to a soft, entrancing realm.

SOFT LIKE FALLING SNOW, crisp like crystal sugar, ribbed like pencil shavings. Draw your sunburst, your dotted orbs, and your jagged drops on the pages with quiet complexity. Move slowly across the page echoing the curved shapes, or introduce sharp lines and oblong structures for more give and take.

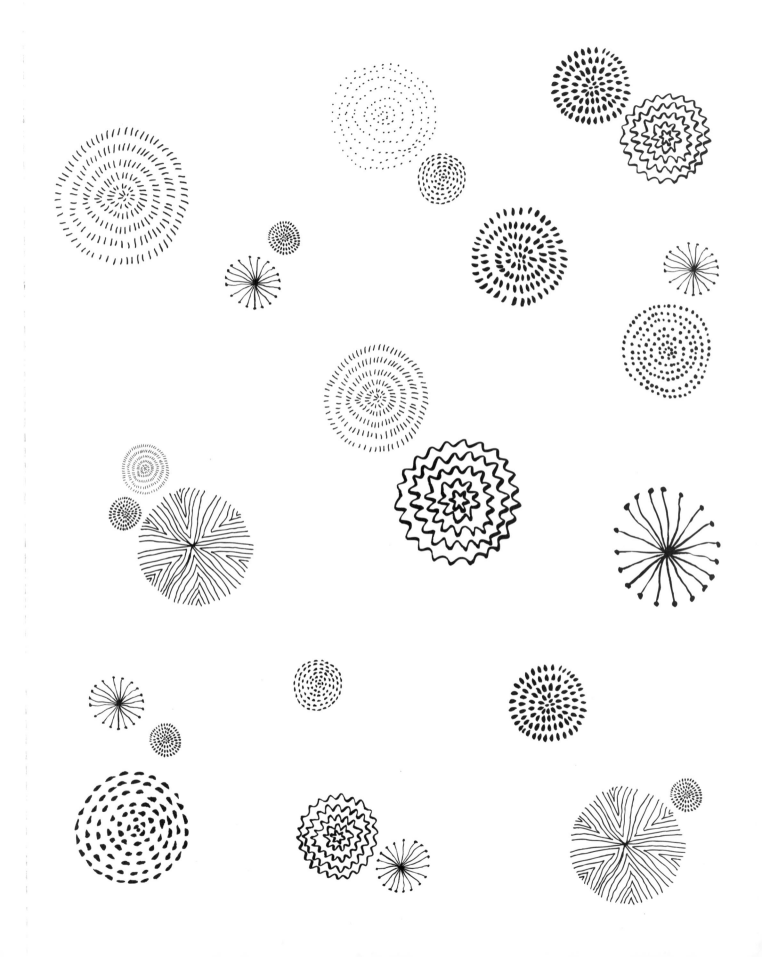

———————❯❯◇◇◇◇◇◇◇◇◇◇◇◇◇◇◇◇◇◇◇❮❮———————

ALL THE WORLD IS HONEYCOMB. Listen to the
soft scuffs of your pen against paper as you enclose each capsule.
One line at a time in soft succession creates depth in each hexagon.
Spread them out across the page or make clusters large and small.

———————❯❯◇◇◇◇◇◇◇◇◇◇◇◇◇◇◇◇◇◇◇❮❮———————

DRAW LUSH GROUND FOR THIS MINI MEADOW

to spring up. Follow the lines that are already there or begin new ones. One stroke at a time, make each flower flourish. Draw a line for the stem, a small circle for the pistils, and hearts, starbursts, and dots for the petals. Let them be free to float in the wind.

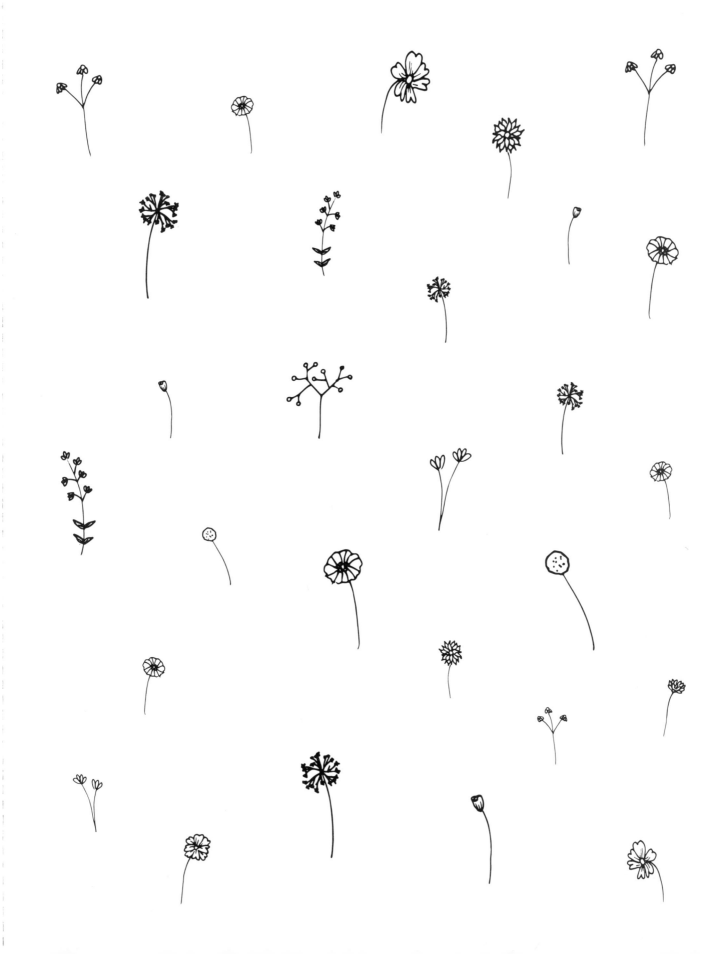

SECRET GARDENS GROW WHERE DEW DROPS FALL
and sunlight sneaks in. Draw the outer shape of the petals,
stems, and leaves using tight or wide lines and arcs. Blooming
from the center or blossoming from the edges, this bouquet
flourishes with curved lines and fine details.

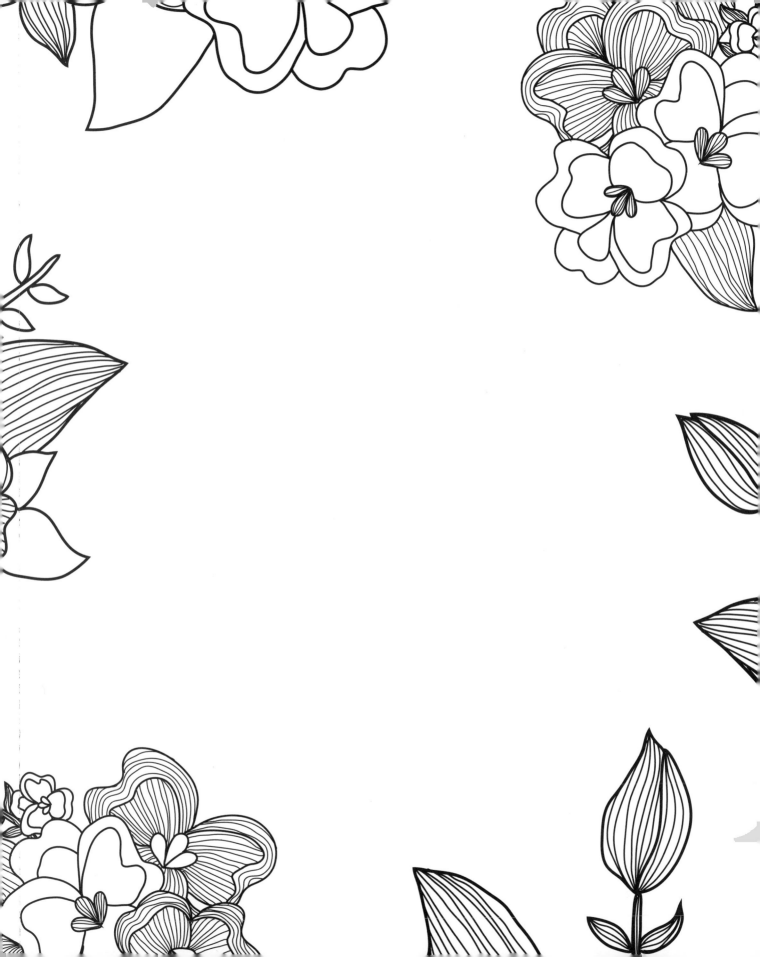

FLORAL FIREWORKS BURST ACROSS THE PAGE.
Like the centers of poppies, the fizzle of streaming firelights, and the gentle rays of sunrise. Connect the contours with straight lines, layered zigzags, or scattered stippling for a melodic moment of creativity.

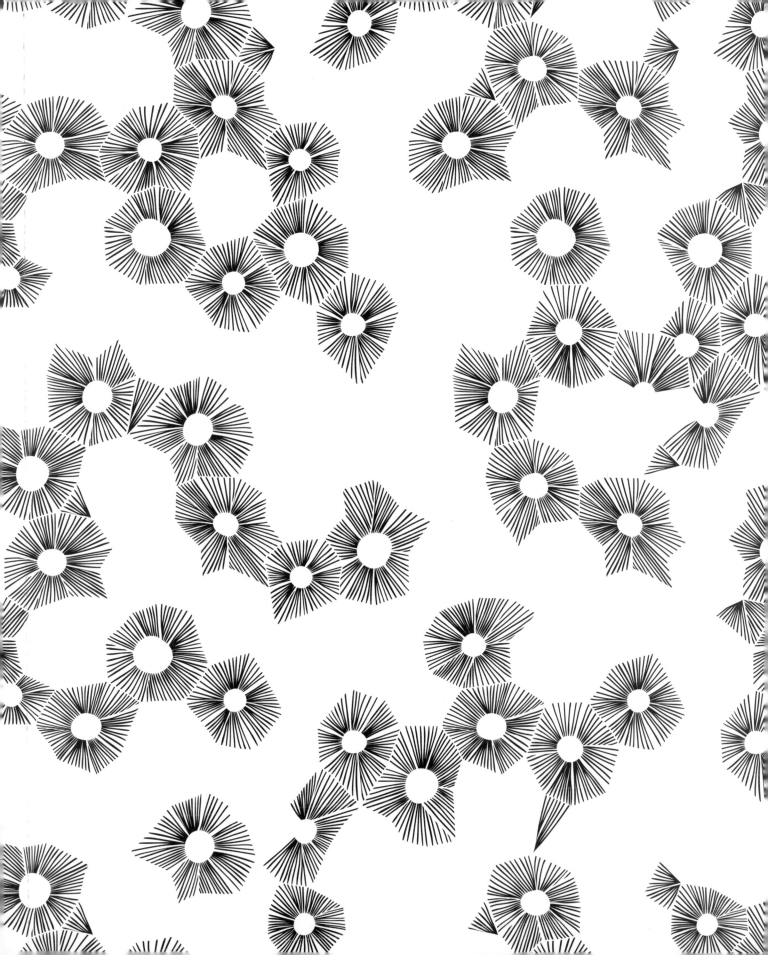

———————×◇◇◇◇◇◇◇◇◇◇◇◇◇◇◇◇◇◇×———————

DESIGN YOUR DAYDREAMS. Fan out the
pattern with repeating bends and turns. Make it an art deco
wallpaper, an etching made of gold, or a field of mushroom
caps with fairies sheltered underneath. Let the curvatures
veer off into unique swirls or an ebbing tide.

———————×◇◇◇◇◇◇◇◇◇◇◇◇◇◇◇◇◇×———————

CRACK OPEN A GEODE and let the light gleam. Connect each sparkling crystal with sharp lines filled with soft impressions and beautiful blemishes. Speckles, bubbles, cracks, and crevices scatter across the surface for mindful meditation.

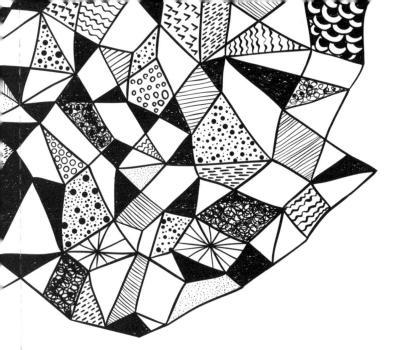

AFFIX FARAWAY GALAXIES or shining disco balls to the canvas before you. Draw rows of tiny, even lines to add to this dappled pattern, or connect the spots with curves, zigzags, or coils. This glittering universe of lines and spheres is infinite until you decide its limits.

WILLOWS WEEPING, VINES CREEPING,

leaves swaying, beads dangling. This canopy is yours to grow one sweeping line at a time. Fasten stars, beads, popcorn, flames, or flowers to each line with simple strokes of your pen.

DANDELIONS EMERGE AND EFFERVESCENT

suds ascend. Repeat the pattern with stems tucked in between each flowered cup, let the pistils blow in the wind, or let the bubbles pop through the air. Make this page your own free-floating retreat.

LAYER YOUR LINES INTO A WAVE-LIKE PUZZLE.

Each module contains its own world and builds something bigger. Tree bark climbing a towering cedar, rice falling through a rainstick, the lens of a microscope seeing more than meets the eye. Connect the shapes or scatter them across the page.

SCATTER HEARTS LIKE CONFETTI. Build on the pattern like crisscrossed yarn over big and small shapes, or open up these hearts to something new: diamonds, triangles, waves, or swirls.

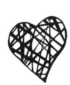

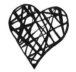
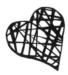

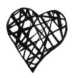

SET NAUTILUS SHELLS across an ocean scene.
Or cluster these swirling snail shells together, large and small.
Begin with a wide spiral in the center flowing out, then draw lines
both across and along for textures only found in the sea.

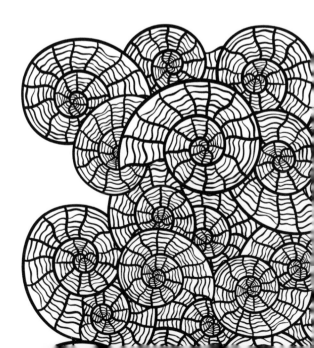

KALEIDOSCOPES OF CHRYSANTHEMUMS TWIRL.

Expand these swirling shapes with soft sketches of bows, arcs, and circles. Build these florals into expansive bouquets or change the shape as you scrawl across the page. Lift your pen for a softer touch, or vary the intensity for a bold effect.

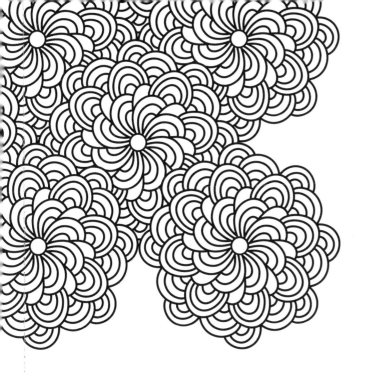

NATURE AND ELEGANCE MEET at the corner of this canvas. Hear the sound of waves as you draw rounded lines of sea-smoothed clamshells. Smell a rose garden as you form soft bundles of circles. Find joy in jeweled doodles.

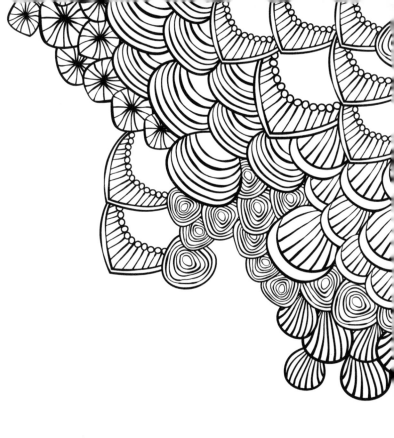

RISE WITH THE MOUNTAINS. Steep angles, earthen edges, and scribbled lines that curve with the crags heading to each peak. Extend these foothills, discover the sky above, or imagine that this is a close look at a tiny world of sharp crystals.

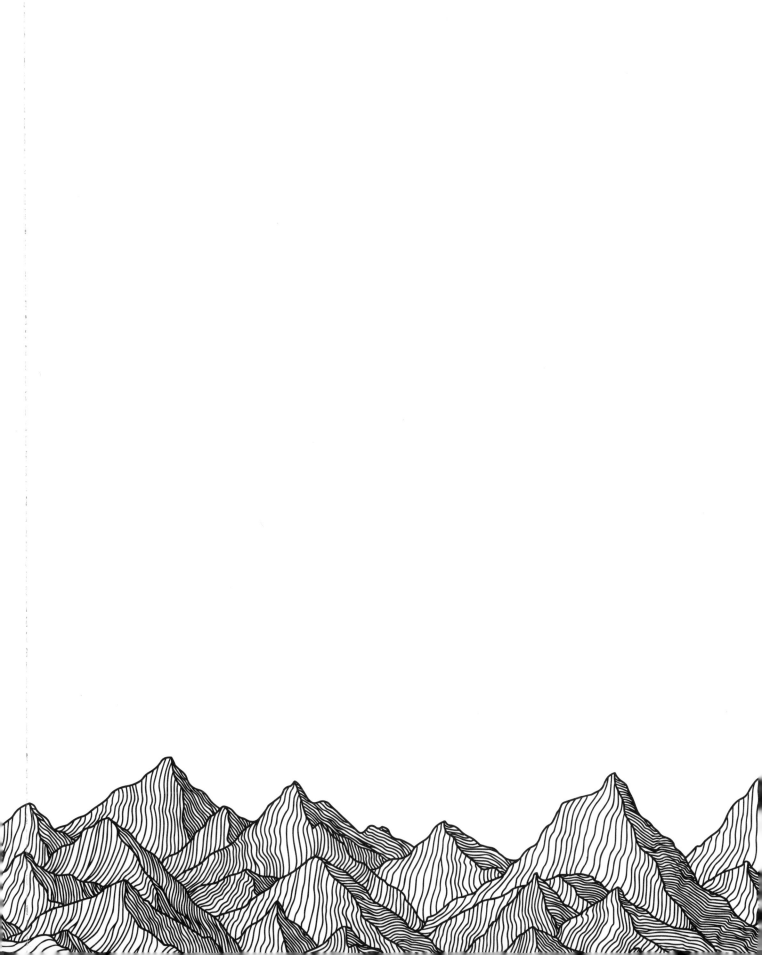

EXHALE LIKE DANDELIONS IN THE WIND.
Flutter like pages of an open book. A gilded pattern or ghostly white, make these lines fan across the page. The soft flick of each mark is a melody for your mood.

◇◇◇◇◇◇◇◇◇◇◇◇◇◇◇◇◇◇◇◇◇◇◇◇◇◇◇◇◇◇◇◇

STRETCH YOUR IMAGINATION. Drag lines
in long, meandering semicircles like surreal, drooping
woodgrain or the gleam of a polished geode. Shade between
the lines or zig zag from end to end until you drift away
with the soothing soothing sound of your pen.

◇◇◇◇◇◇◇◇◇◇◇◇◇◇◇◇◇◇◇◇◇◇◇◇◇◇◇◇◇◇◇◇

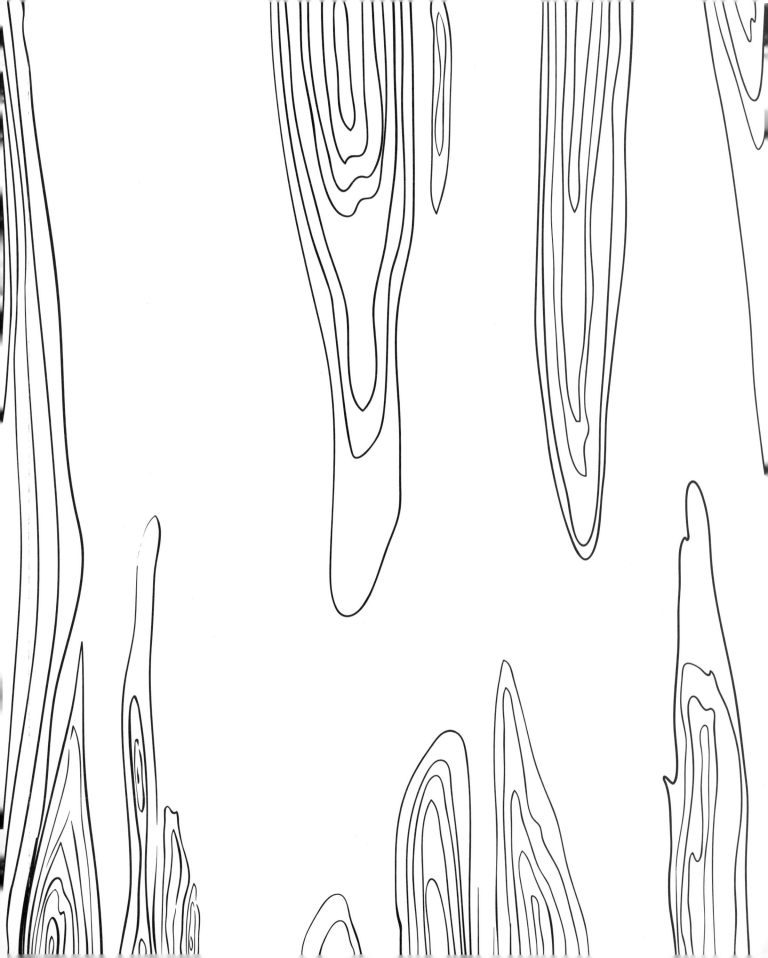

ALL PATHWAYS LEAD FORWARD.
Send pyramids and arrows streaming across the page.
Sprinkle circles, stars, and undulating lines to complement
the sharp angles tracking across the space.

PAISLEY PRINTS, DROPS OF COLORING in a bowl of water, leaves on a vine. Color in the pattern with medium and large teardrop shapes. Draw the outlines and let the ink rest inside the lines as if to flood it from edge to edge.

CREATE YOUR CALM. Set your pen to
the page and take a deep breath in as you draw each
corner of a box. Exhale deeply and move your way through
a series of peaceful, cascading cubes.

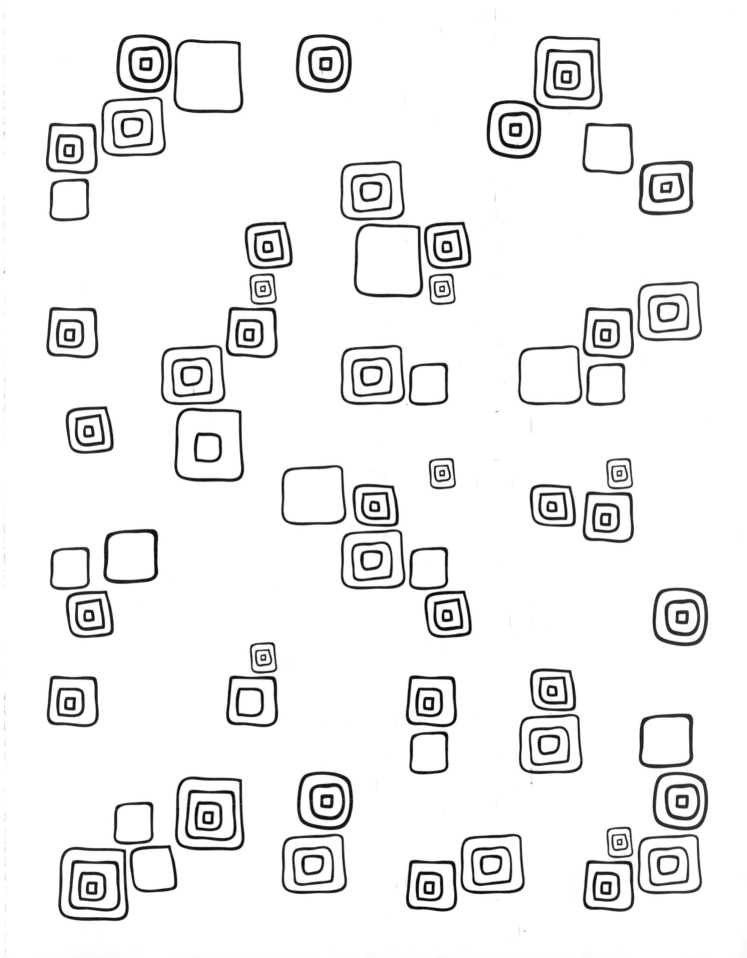

UNROLL STREAMERS ACROSS THE ROOM,

decorate abstract waves with sharp angles, or let the lines take you somewhere new. Fill in this wild stretch with unexpected detail. Like the stripes of a zebra, no two bands look alike.

HUM ALONG THIS PATHWAY OF ARROWS.

Choose a new direction and mark down one arrow at a time, shading in the lines where you choose or adhering to the pattern. Dip the tip of your pen down and let the ink run for each dot, or expand them into coins.

TRAVEL TO A BUTTERFLY GARDEN full of lush colors and pleasant aromas. Let the wings of these beauties carry you to a sense of calm. Follow the shape of their wings or draw circles to achieve abstract silhouettes in flight.

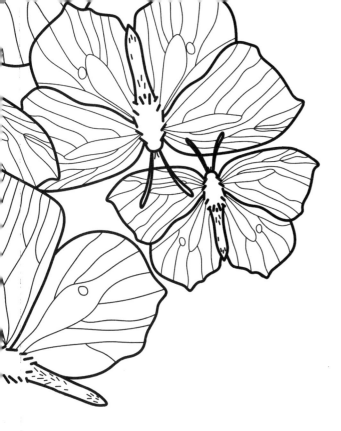

A CHEVRON PATTERN AS ETHEREAL as a peacock's feather, this series of lines will send you into meditation mode. Extend the lines, one at a time, with tiny spots of ink heading in ascension and descension as you move across the page.

ABSTRACT ART IN A PATCHWORK PORTRAIT.

Expand this space *without* intention. Scatter lines, stipple dots, sprinkle stars, and skim stripes from end to end of each swatch. Stitch it all together in organized chaos or in calm creativity.

FOCUS ON THIS FLORIOGRAPHY.

Track your pen across the page, following the patterns of the flowers and stems before you. Speckle dots here and there like dew drops in the morning.

CURLING TRESSES, SWIRLING SMOKE, or gravity-defying waves. Continue the eddies across the page, letting them churn in new directions. Listen to the peaceful sounds of the pen or imagine you can hear waves just outside your door.

FALL INTO THE RHYTHM of this whirling pattern. With careful lines so small they look like dots, make a maze of pathways and curling arches. Send them billowing across the sky like clouds on a windy day.

—————⟫◇◇◇◇◇◇◇◇◇◇◇◇◇◇◇⟪—————

SCORE THIS PAGE WITH THE INTENSITY

of a conductor. Drag the lines in succession—*one, two, three, four, five*—and pivot your pen. Again. Let the cadence of your movements and the sound of the ink against the page lull you into a relaxing space.

—————⟫◇◇◇◇◇◇◇◇◇◇◇◇◇◇◇⟪—————

FAN WITH FLAIR. Expand the arcs with new patterns, lay out necklaces strung with exotic beads, or repeat the patterns on the page bit by bit. Tune into each bit of pattern, connecting them with ease.

TINY UNIVERSES THRIVE inside these pyramids. Draw out triangles of the same size. Transform them from lines on a page to three-dimensions, drag lines from the outside corners to the center. Carve out your configurations with steady ease.

PETALS LIKE NO OTHER, let the patterns grow. Unfold the shapes outwardly, expanding petals and verdures across the space. Turn an abstract eye toward your pen and create shading with soothing specks or lines so dark they shimmer like polished obsidian.

FEATHERS FROM A SOARING BIRD float up gently.
Turn to the opposite side of the page and send your drawings
reaching for the ink already on the page. Draw the spine down the
center of your plume and flick gentle lines away for feather quills.

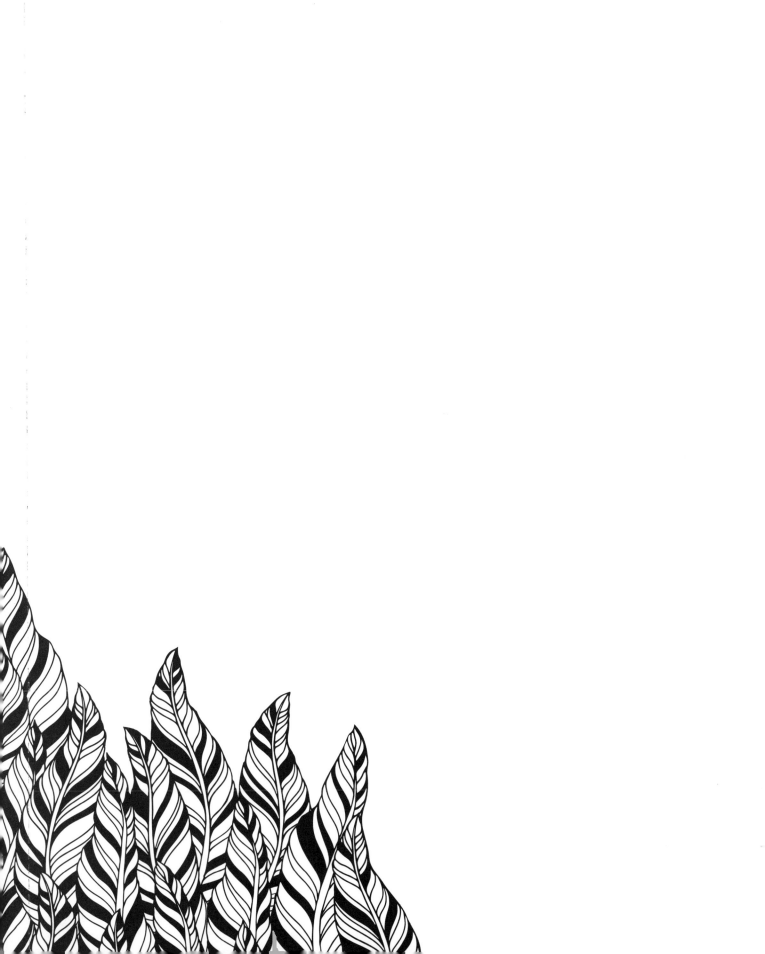

LIKE RIBBONS IN WATER, this ink drifts on by. Let your lines ebb and flow, closing in tightly to turn the shape and loosening to let it go. Immerse yourself in the movement of your strokes and let the pattern wash over you.

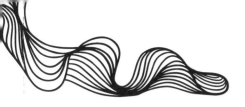
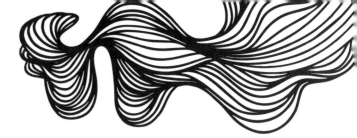
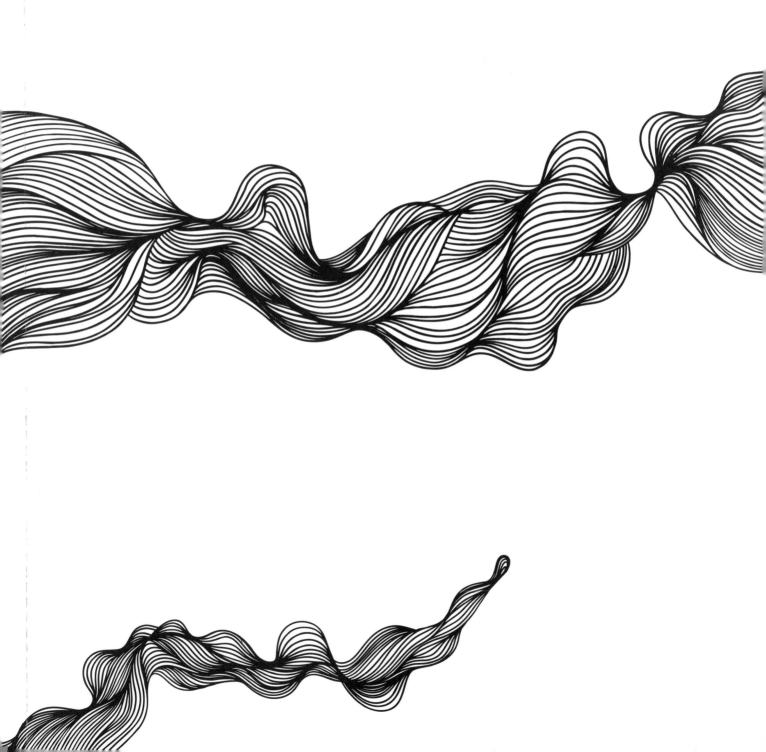

SUMMER FANS WAFT IN SUMMER BREEZES.

Scallop these edges with messy flicks of your pen tip in rapid motion or with defined, careful shapes to mirror the pattern precisely. Hear the rush of the ocean or the rustling of the air.

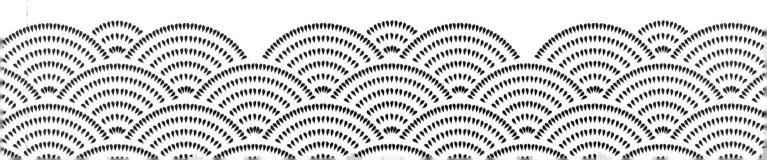

PLAY WITH LIGHT, SHADOWS, and silhouettes in this blossoming garden. Tighten your grip on your pen for dark outlines and let your muscles relax for a softer touch. Play with blacks and grays, or blend in color as bursts of life shining through.

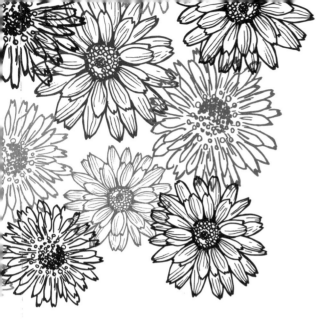

GET SETTLED IN STACKING PATTERNS.

Mirror the design's order by working backward from the small circles, repeating each section segment by segment. Find comfort and control in immersing yourself in the repetition of lines that zip, curve, and cave.

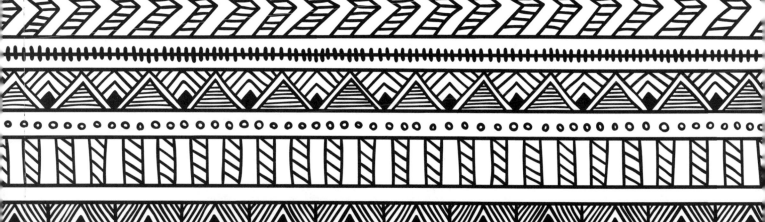

THERE'S MAGIC IN THE MOUNTAINTOPS.

Give each drip castle, sand dune, or snowy peak its own expression with loops and lines in different varieties. Connect the hills together like a captivating range, or set the crests apart for endless views.

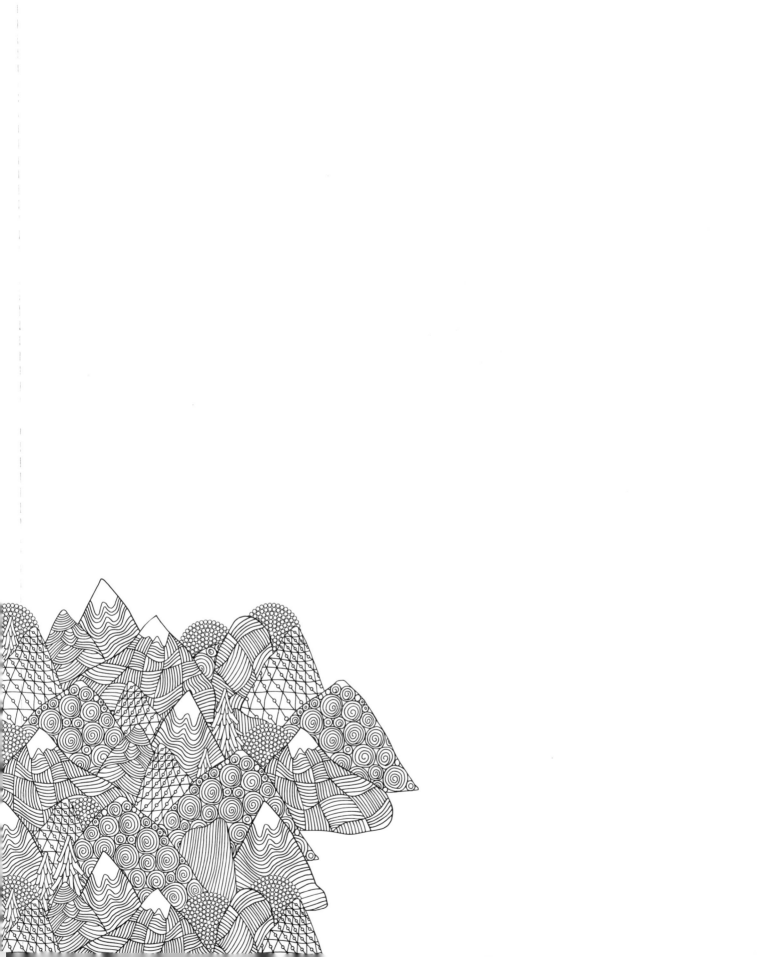

PEEPHOLES IN PAPER, abstract orbs scattered like marbles, or galaxies you dream of reaching. Each circle contains multitudes. Connect them like constellations or encircle your own patterns across the page.